MEDIEVAL FASHIONS

TOM TIERNEY

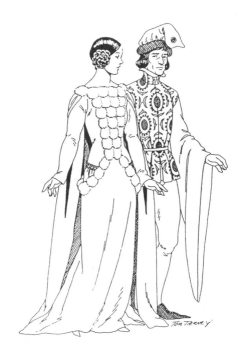

DOVER PUBLICATIONS, INC.
MINEOLA, NEW YORK

INTRODUCTION

The medieval era, or Middle Ages, is defined by historians as the period in western European history between the fall of Rome in the fifth century and the rise of the Renaissance in the mid-fifteenth century. The fifth through the eighth centuries have been called the Dark Ages. Fashions during this time, overall, continued to reflect the influences of the Greek, Roman and Byzantine cultures.

The illustrations in this book begin with the Franco-Norman era of the Middle Ages when feudal society became well established. With the rise of the feudal system in the late 800s, style and extravagance of dress became a reflection of one's position in society. By the late 1400s, the cost of clothing and the lengths of items such as hoods, trains and shoes became regulated by sumptuary laws which remained in effect until the early sixteenth century.

Among the earliest articles of clothing from this time was a tunic with long sleeves called a bliaud. It was worn knee length by men and floor length by women. By the eleventh century, men wore the bliaud lengthened to the ankle. But at the end of the thirteenth century, the bliaud, then called a tunic, was worn by young men a mere few inches below the waist, which some people considered outrageously short.

The bliaud covered a chainse, or under-tunic, usually colored saffron yellow. Originally made of heavy wool, linen or hemp, the chainse eventually evolved into a piece of lingerie made of sheer, washable fabric. Another garment worn by men and women was the mantle, a luxuriant cloak fastened in front by a large brooch, buckle, or pin.

Increased trade with the Orient and Far East brought new dyes to Europe which were used to produce fabrics in brilliant shades of scarlet, green, blue and purple. While materials tended to be rich and heavy, embroidered or fur trimmed, at this point, delicate linens, embroideries, velvets, and sheer gauzes became available.

In the thirteenth century, the French weaver Batiste Chambray invented a closely woven, sheer fabric called batiste which inspired the creation of the surcoat. Based on the sleeveless, cloth covering worn over armor by knights to fend off the glare of the sun, the surcoat was adopted by both men and women as a replacement for the bliaud.

The woman's surcoat was now open at the sides to reveal a fitted dress with long buttoned sleeves called a cote-hardie. This style was vehemently frowned upon by the church as being too revealing. Men wore the cote-

Bibliographical Note

Medieval Fashions Coloring Book is a new work, first published by Dover Publications, Inc., in 1998.

DOVER *Pictorial Archive* SERIES

International Standard Book Number: 0-486-40144-8

Manufactured in the United States of America
Dover Publications, Inc., 31 East 2nd Street, Mineola, N.Y. 11501

hardie too, cut shorter. Both men and women wore jeweled hip girdles, or belts.

In the fourteenth century, parti-colored clothes became the rage, first with men and then with women. Garments were divided into halves or quarters; each section was sewn from a contrasting color. Shoes and stockings were different colors as well.

By the fifteenth century, the surcoat began to disappear. Women wore a belted dress called la robe which had a long sleeved, fitted bodice joined to a full skirt. Men wore jackets that covered a quilted garment with or without sleeves called a pourpoint. Originally worn under armor, the pourpoint evolved into a vest.

For outerwear, women wore flowing capes which were lined with fur in winter. A popular men's cloak was the houppelande. A trailing robe with long bishop's sleeves, the houppelande was fastened in folds at the waist by a jeweled belt.

Sleeves became important, particularly on the surcoat and the houppelande. While some sleeves hung over the hand, others were dramatically longer, with openings at the elbows for arms to extend through. Another style of long sleeves was called the dogaline. The sleeve openings, the size of large circles, were folded back and fastened to the shoulders, revealing a rich fabric or fur lining.

Dagged edges, a petal-like scalloping, were popular decoration for all parts of clothing from hats to houppelandes; only stockings escaped this kind of embellishment. Small silver bells, favored ornaments for men and women, appeared on belts, girdles, baldrics (a belt or sash slung across the body from the shoulder to the opposite hip), hats and the toes of shoes.

Head coverings for men included skullcaps, helmets, peaked bonnets, and hats with rolled brims. Crusaders sometimes wore straw hats over their metal helmets to deflect the sun. By the eleventh century, soft fabric caps with peaked tops were in general use. Men also wore toques or bag caps. Full and round, they were gathered onto head-bands. Sugarloaf shaped hats made of felt were worn with and without brims. Feathers as hat ornaments first appeared in the medieval era; the peacock plume was most popular.

By the twelfth century, the chaperon, a hooded cape, became the most common headgear for men. While the hood remained in fashion through the sixteenth century with only nobles allowed to wear long hoods, during the fourteenth century, the peak of the hood lengthened into a liripipe. A streamer of gauze or ribbon which sometimes reached the floor, liripipes were also restricted to use by nobility. Over the years liripipes grew to such outrageous lengths that some men wrapped them around their wrists. Stuffed turbans, called roundlets were trimmed with liripipes too.

During the Middle Ages, the Christian church required that women cover their heads. The predominant head covering for women was a square,

oblong, or round piece of fabric called a couvre-chef, also called a wimple or a headrail. In earlier centuries, the basic headrail was wrapped around a woman's neck and shoulders, held in place by a circlet or crown. Beginning in the twelfth century, the wimple became a longer length of fabric, usually white linen, which was drawn up under a woman's chin and fastened on top of her head. Over the wimple, women wore a separate couvre-chef which was held in place by a crown or circlet. Variations of these headdresses survived in many religious orders until the twentieth century. In the twelfth century, blonde hair was fashionable. Some women sat for hours on enclosed terraces waiting for the sun to bleach their tresses; others used false hair and cosmetics. During the thirteenth century women began to wear small, crown-like toques, a head-band and chin-band, all in white linen. In the fourteenth century the caul came into fashion. This style concealed a woman's hair in a silken case covered with a heavy net of jeweled silver or gold cord. Hair coverings varied widely, from a simple snood-like net to cylindrical cauls worn on either side of the face, to a padded horn or heart-shaped headdress fastened over the caul. Women often wore sheer veils on top of the entire combination. They plucked the visible hair at the napes of their necks, at their temples and thinned their eyebrows.

In the fourteenth century, the hennin, or steeple headdress, was introduced by Isabella of Bavaria. A tall cone, it had a black velvet band across the top of the forehead. Always draped with a floating or wired veil, the height of the hennin became so extravagant that the authorities imposed regulations here too. The higher the hennin, the more exalted a person's place in society.

The chin-band came into style during the fifteenth century. A folded white linen wrapped under a woman's chin, fastening to a band around her forehead. In another style of head covering, a stiffened head-band was shaped into a low toque or crown-like headdress.

Men and women wore similar soft leather or fabric shoes with elongated toes. These low cut shoes buttoned or tied at the ankle. Soft and pliable, they were made of velvet or gold cloth and decorated with embroidery, strips of gold, and gems. One men's style, the poulaine, had pointed toes which became so long that they had to be stuffed to hold their shapes. Eventually the exaggerated toes were held up by fine chains attached to the knees. Also called a poulaine was a clog or patten made of wood, which was worn to protect the soft soles of shoes.

Men wore fitted and sewn stockings or tights. Made of bias cut material, they were decorated with jeweled garters. Stockings, held up at the waist with a belt or tie, were cross-gartered on the lower leg with bands of fabric or soft leather.

Heavy chains and jeweled belts were popular accessories among wealthy people who used them to carry pouches, purses, and daggers set with precious stones.

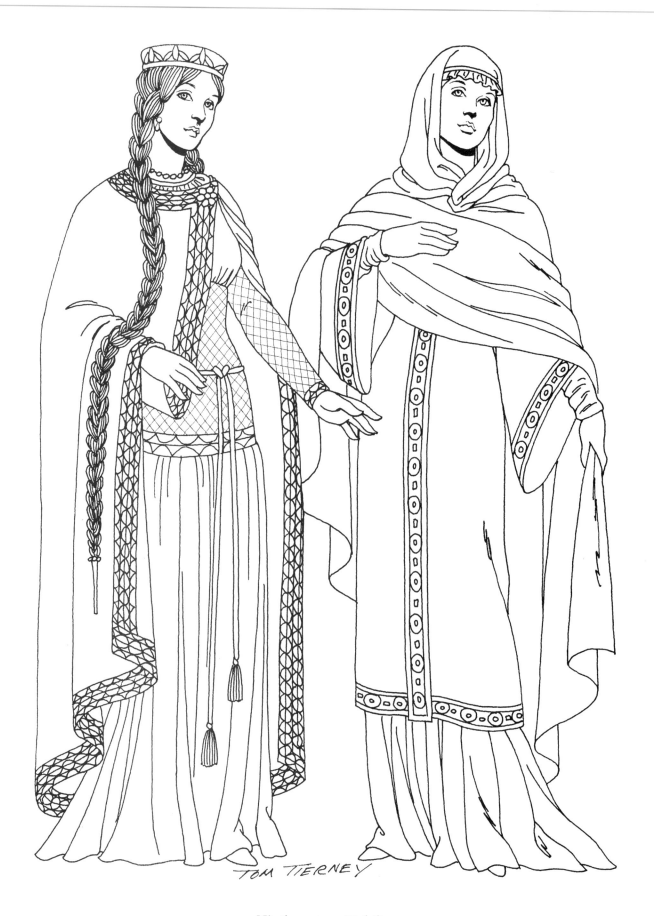

TOM TIERNEY

Ninth-century Nobility

Left: The Frankish noblewoman wears a mantle over a mail girdle with mail sleeves over a bliaud. **Right:** The Norman noblewoman is wearing a mantle, bliaud, and chainse.

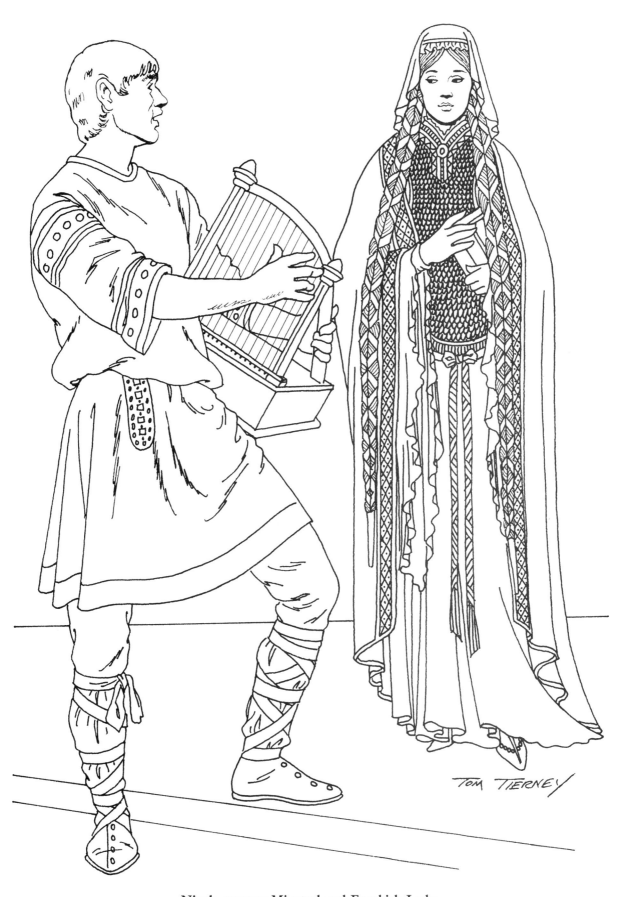

Ninth-century Minstrel and Frankish Lady

Left: The man is wearing a bliaud over cross-gartered tights. **Right:** The lady wears an embroidery-edged mantle over her bliaud. Her plaited braids are decorated with metal tips and a couvre-chef.

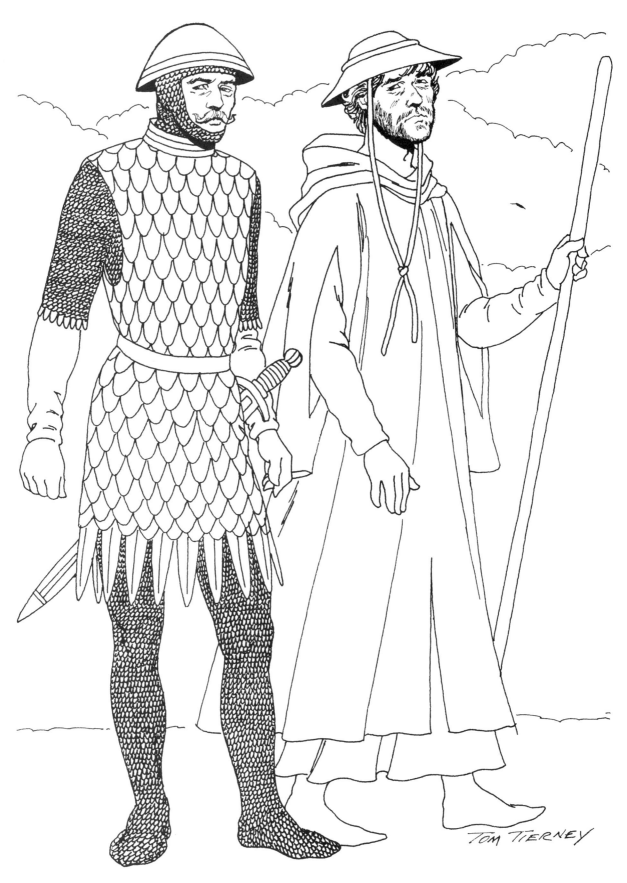

Ninth-century Soldier and Pilgrim

Left: The soldier wears metal chain mail armor over a long sleeved tunic. The boiled leather cuirass, another type of defensive armor, is worn over the chain mail. On his head is a boiled leather hat. **Right:** The pilgrim is wearing an early version of the cote-hardie over a bliaud accessorized with a felt hat.

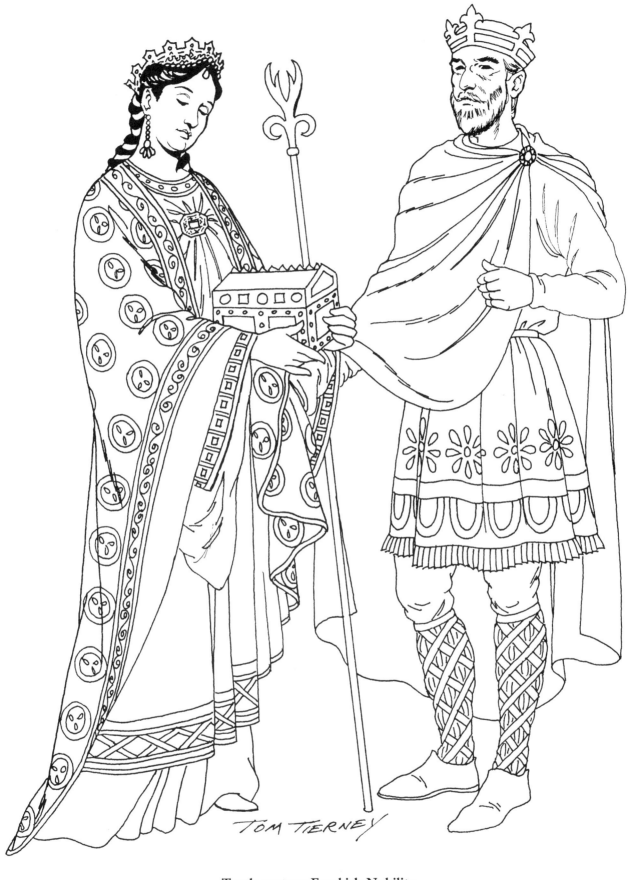

Tenth-century Frankish Nobility

Left: The Frankish noblewoman wears an embroidered mantle over a bliaud, and chainse. **Right:** The nobleman is wearing a mantle over an embroidered tunic, cross-gartered stockings, and soft leather shoes.

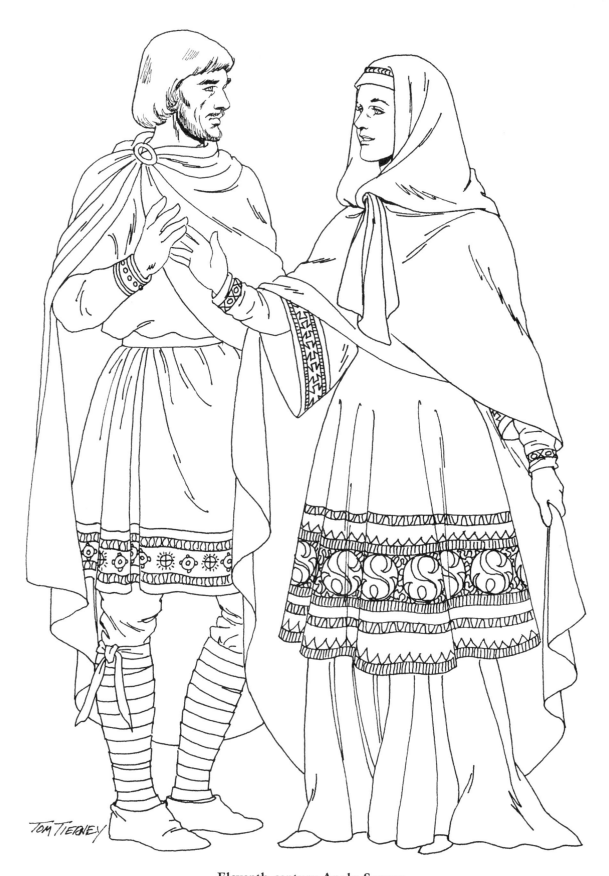

Eleventh-century Anglo-Saxons

Left: The nobleman is wearing an embroidered tunic or sherte (the word shirt comes from it), a chemise type garment with sleeves, a mantle, and cross-gartered breeches. **Right:** The noblewoman wears an embroidered bliaud over a chemise with embroidered cuffs. She wears a mantle and a headrail. Her fitted waist, a fashion innovation, was accomplished with lacings down the back.

8

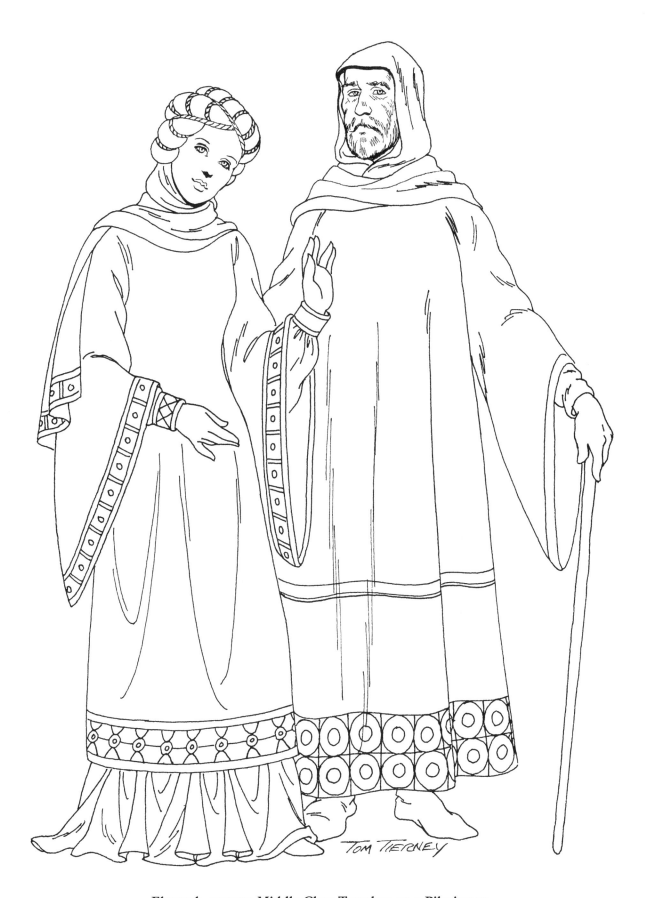

Eleventh-century Middle Class Travelers on a Pilgrimage

Left: Over her chainse, the woman wears a fitted bliaud with angel sleeves. Both garments are decorated with embroidery. Her headrail, worn over a wimple, has been twisted and bound into a turban. **Right:** The gentleman wears a long bliaud with angel sleeves and embroidery at the skirt hem. His hood extends into a shoulder cape.

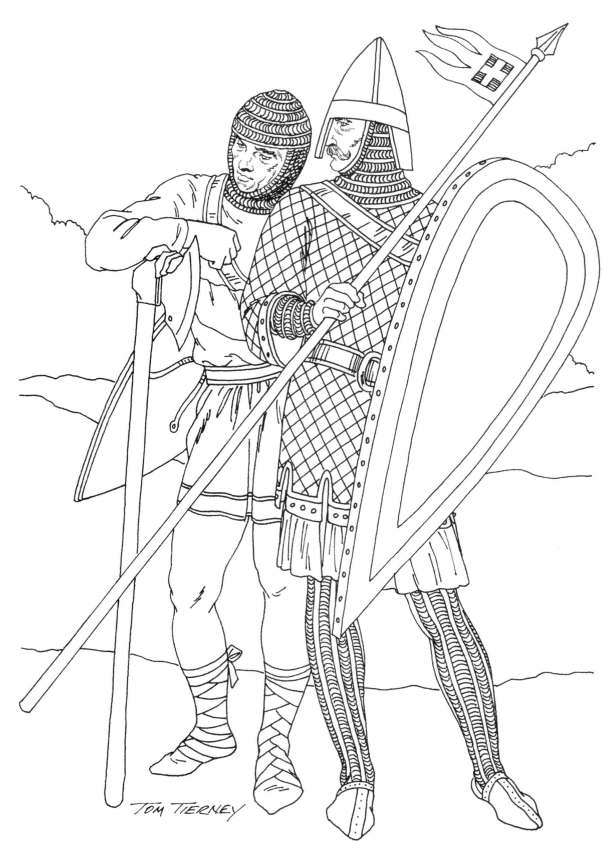

Eleventh-century Soldier and Knight

Left: The foot soldier wears a short tunic, cross-gartered tights and leather shoes. A chain mail hood covers his iron skull-cap. Over his chest he wears a leather baldric, a diagonal sash for carrying a shield and knife; he holds a battle ax. **Right:** The crusader knight is wearing a metal battle helmet, or spangenhelm, over a chain mail hood. He wears a soft under-tunic or pourpoint covered by his tunic of hardened leather tiles. His arms and legs are protected by fitted chain mail sleeves and leggings; his shoes are leather.

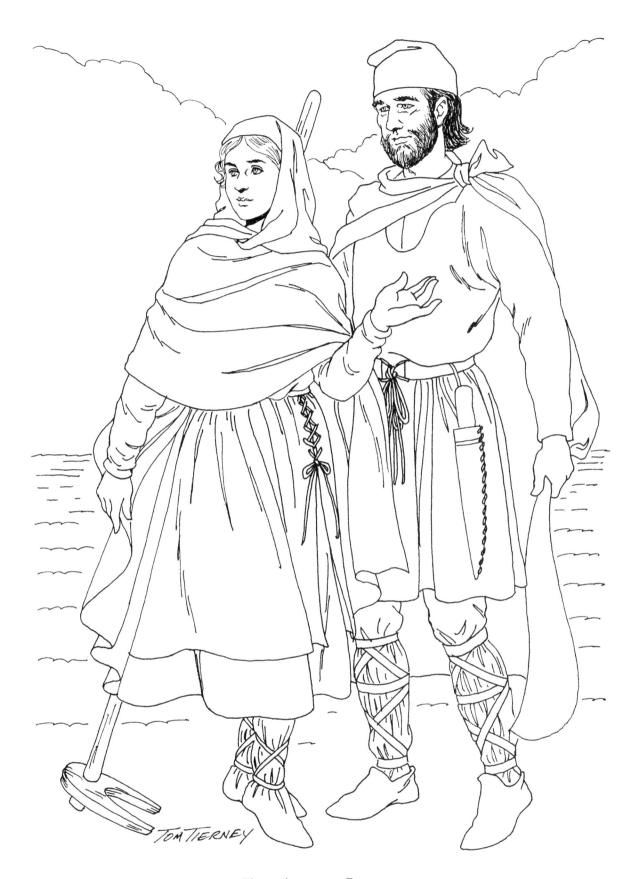

Eleventh-century Peasants

Left: Under her cloak, the woman wears a bliaud covered with an apron which is laced for fit. She wears cross-gartered, soft leather stockings. On her head is a headrail. **Right:** The man wears a short tunic over loose drawers which are cross-gartered. His cloak is tied at the shoulder. On his head he wears a peaked cloth or phrygian helmet-shaped cap. His shoes are leather.

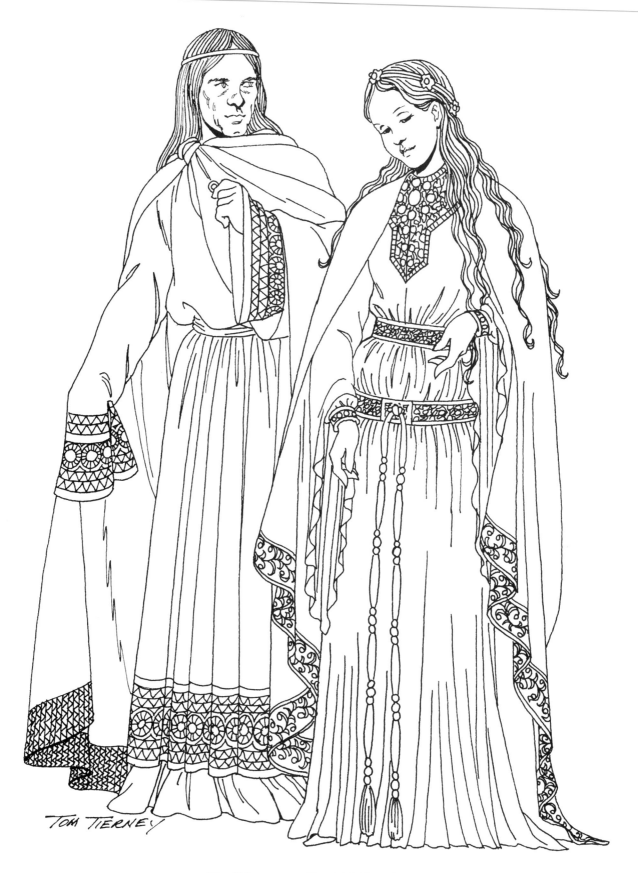

Twelfth-century Frankish Royalty

Left: The Frankish prince wears a long, elaborately embroidered bliaud with extremely long sleeves, perhaps to keep his hands warm. His chainse is floor length. Tied at the shoulder, his mantle has an embroidered band at the bottom. **Right:** The princess wears an outfit with finely embroidered trim. Circling her long bliaud is a double girdle of jeweled leather with silk ties.

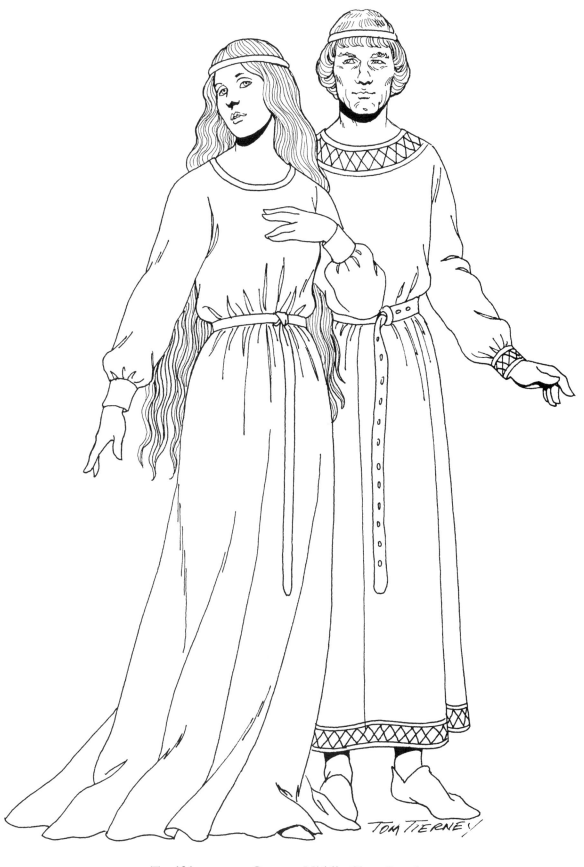

Twelfth-century German Middle Class Couple

The man and woman each wear a bliaud with a long leather belt and soft leather shoes. The man's bliaud is edged with embroidery.

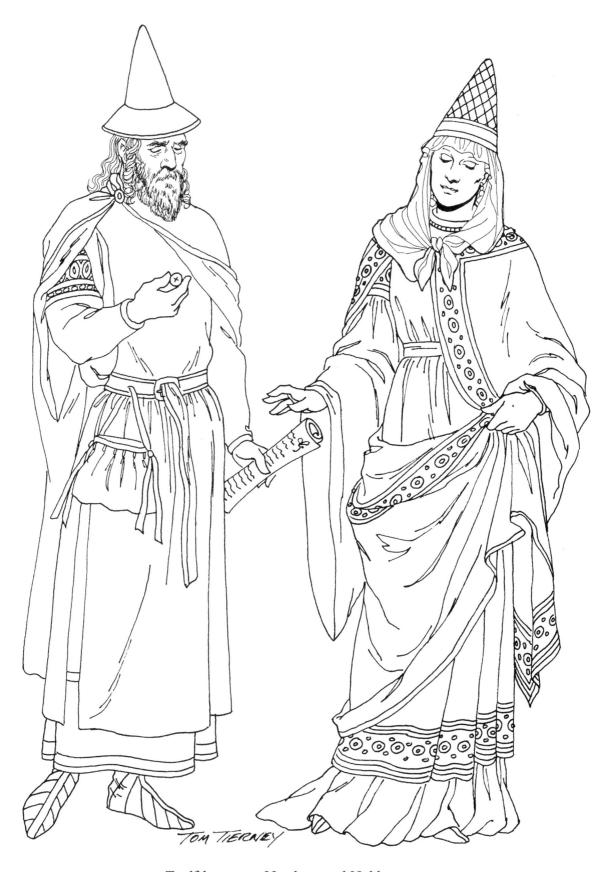

TOM TIERNEY

Twelfth-century Merchant and Noblewoman

Left: The commoner merchant wears a belted surcoat over a bliaud. His mantle fastens at the shoulder; a pouch hangs from his belt or girdle. On his head is a conical felt hat. **Right:** The woman wears a short-sleeved bliaud over a full-sleeved chemise, and a long mantle over all. The mantle and bliaud are edged with jeweled embroidery. Her head gear includes a conical hennin, or high headdress, over her headrail, or veil.

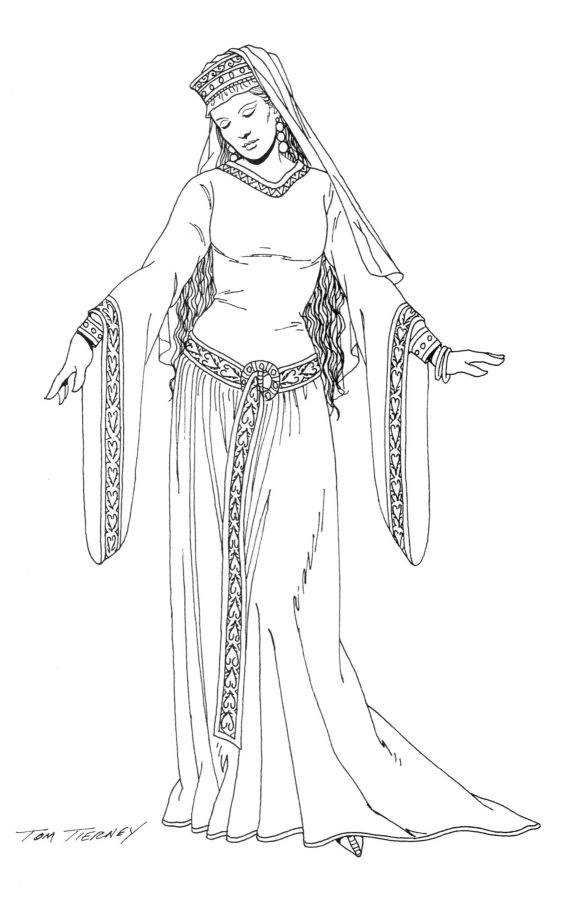

Twelfth-century Norman Noblewoman

This noblewoman wears a fitted gown which is laced in the back. Her full skirt is gathered under an intricately embroidered girdle or belt with embroidery matching the angel sleeves. Her crown is layered between a shortened headrail and a long veil.

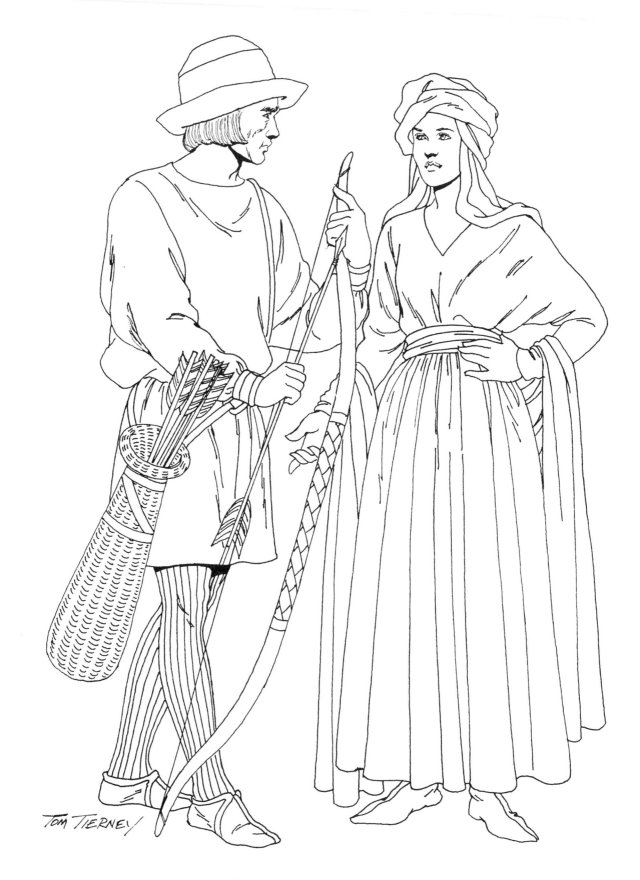

TOM TIERNEY

Twelfth-century French Commoners

Left: The hunter wears a short tunic with batwing or dolman sleeves. Bloused fabric at his waist covers a belt. He wears knitted stockings, low cut leather shoes, and a felt hat. A wicker arrow quiver hangs from his waist and he holds a long bow. **Right:** Carrying a shoulder scarf or stole, the townswoman wears a belted bliaud with dolman sleeves. Her headrail is wrapped like a turban.

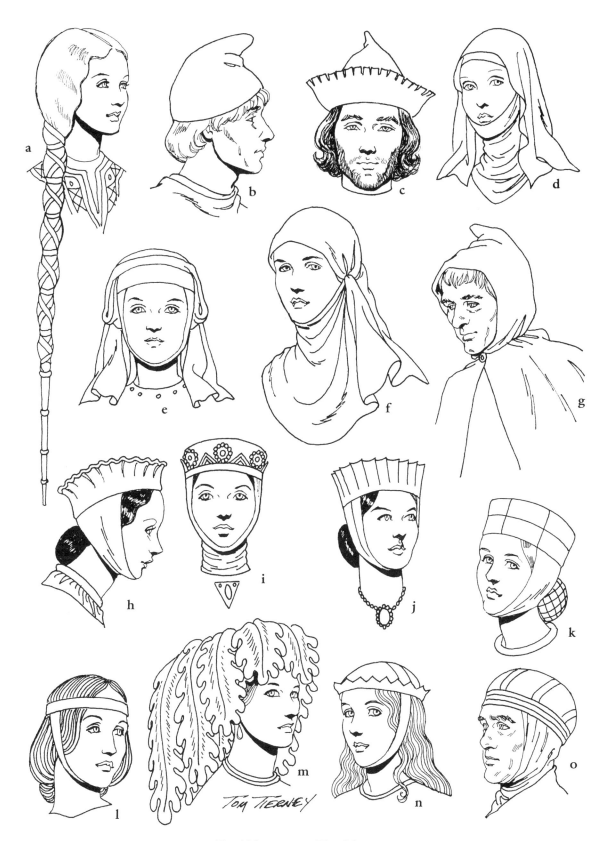

Twelfth-century Headdresses

a. Long plaits bound with ribbons with metal cylinders covering the ends. **b.** Phrygian or close fitting cloth cap. **c.** A peaked hat made of felt with castellated brim. **d.** Linen gorget, or collar. **e.** Folded wimple worn over chin strap cap. **f.** Wimple. **g.** Hood and cape. **h.** White linen toque with pie crust edging worn over chin-band. **i.** Jeweled velvet toque worn over gorget and chin-band.

j. Chin-band and toque of pleated linen. **k.** Toque worn over a chin strap cap with net caul covering hair. **l.** Chin-band and head-band of ribbon. **m.** Turban with moiré leaves. **n.** White linen cap and chin-band under a gold crown. **o.** Men's version of the wimple with banded wool cap.

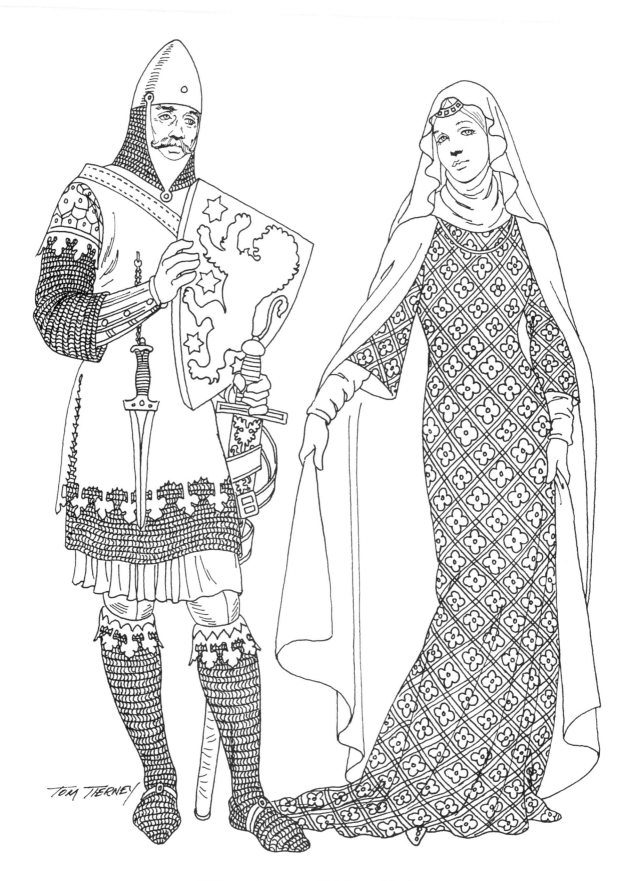

Thirteenth-century Knight and Lady

Left: The crusader knight wears a chain mail hood under a steel helmet with a chain mail tunic, leggings, steel knee guards and shoes. Over the tunic he wears a surcoat with dagged edging. **Right:** The English noblewoman is wearing a white linen wimple and gorget with a jeweled circlet. Her diapered pattern bliaud covers a white chemise. Covering all is a full mantle with contrasting lining.

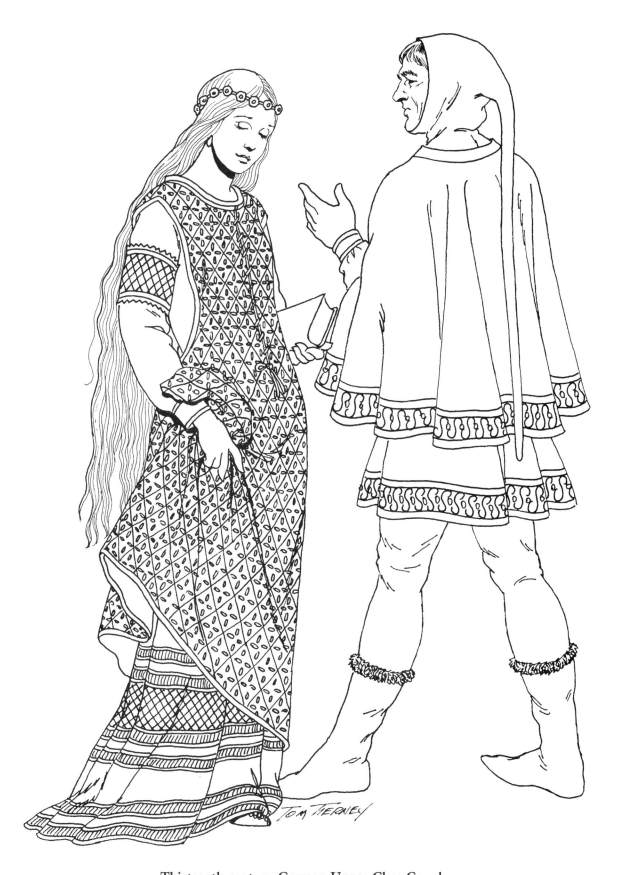

Thirteenth-century German Upper Class Couple

Left: The maid wears a front laced, diapered surcoat over a heavily embroidered short-sleeved bliaud and simple chemise. On her head is a jeweled circlet. The lack of a headrail or wimple indicates that she is a maiden.

Right: The man wears a hood with a liripipe under his cape and tunic. He wears wool tights and soft leather, fur trimmed boots.

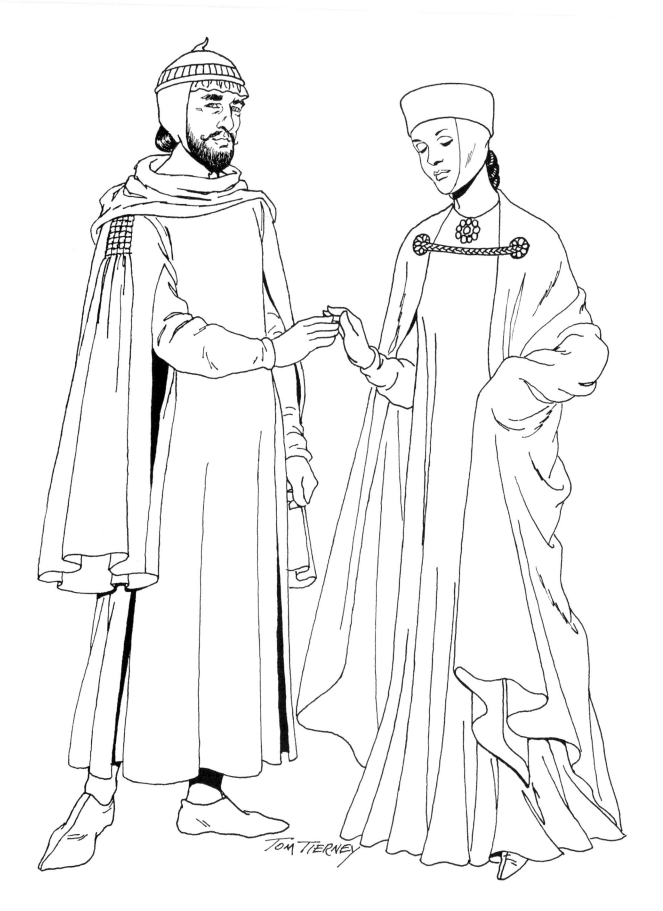

Thirteenth-century French Upper Class Couple

Left: The man wears a surcoat or garde-corps with hanging sleeves over his bliaud. **Right:** The woman wears an ungirdled gown under her mantle. Both wear chin strap caps under their hats.

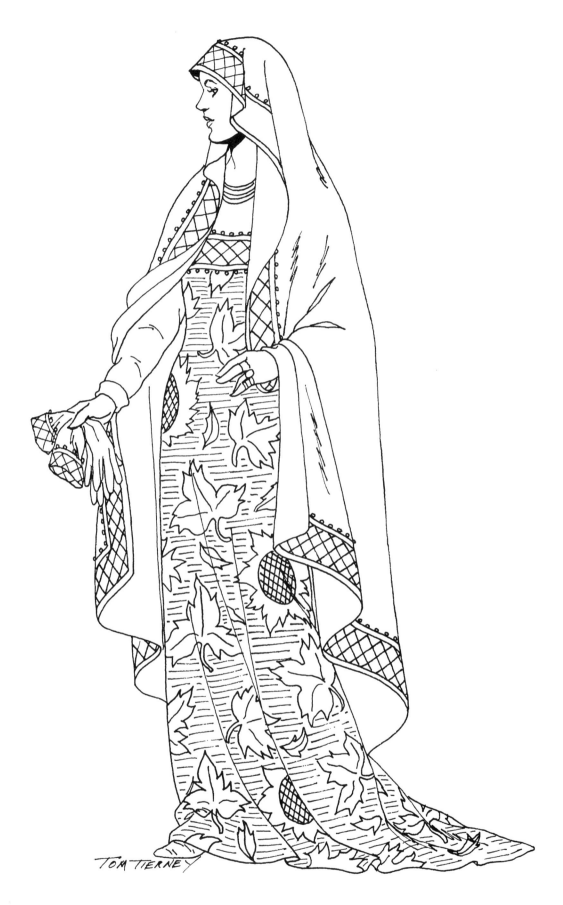

Thirteenth-century Italian Lady

The lady wears an embroidered and jeweled mantle over her head and shoulders. Her robe is brocaded silk. Her gloves are embroidered and jeweled.

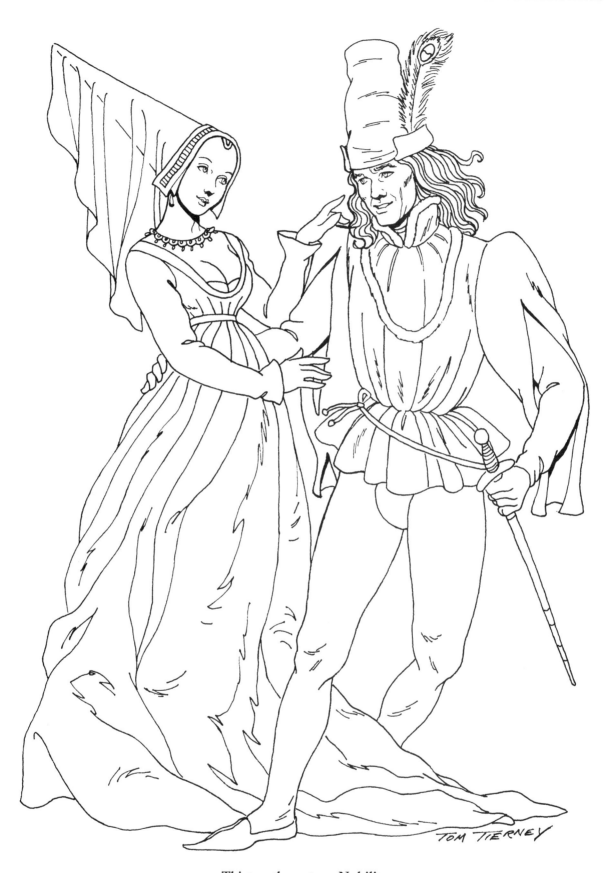

Thirteenth-century Nobility

Left: The waist of the noblewoman's gown has moved to just under the bosom; the skirt has an extremely long train. She wears a steeple hennin with a loose veil. **Right:** The gentleman's cote, or jacket, is cut short, showing his legs to advantage. Featuring padded and puffed shoulders and slashed hanging sleeves, his cote has a fur trimmed collar. Around his neck he wears a circlet of fur.

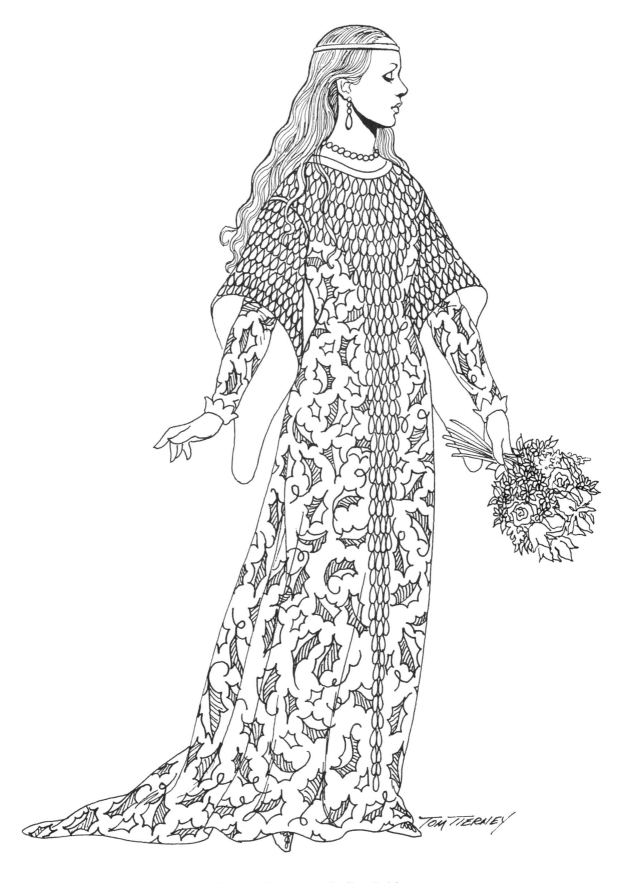

Thirteenth-century Italian Bride

This young woman wears a robe of brocaded silk, shot with gold or silver threads. The panel down the front has metallic spangles and she carries a bouquet of flowers.

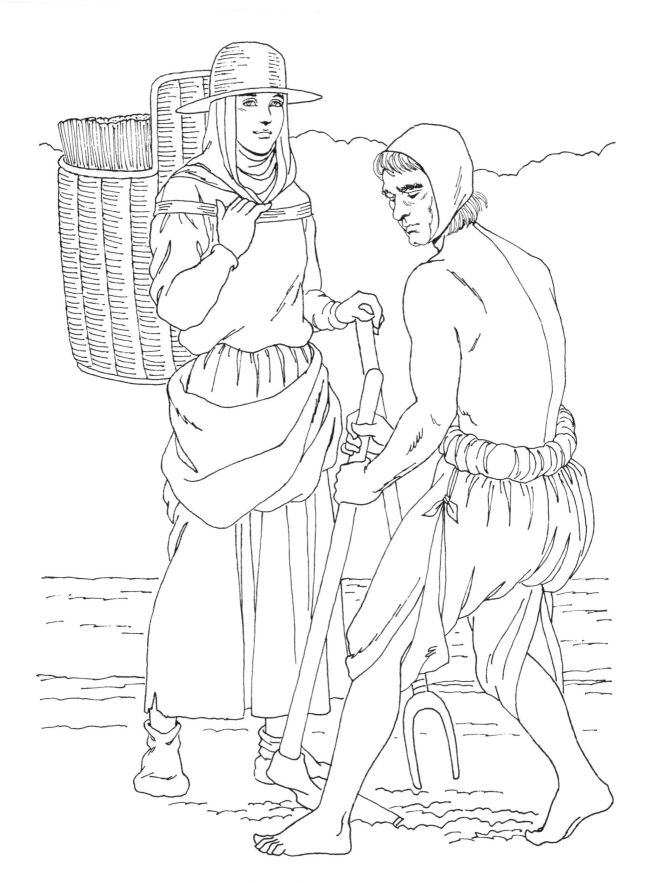

Thirteenth-century Peasants

Left: This farm woman wears a wool bliaud, belted and bloused at the waist. Under her straw hat she wears a kerchief tied to form a gorget. She wears soft leather shoes. **Right:** The man has removed his tunic and we see his braes or breeches which are gathered and tied at the waist. The legs are caught up and tied to pointes at the waistband. He wears a cap with chinband. His feet are bare because he is saving his shoes for special occasions.

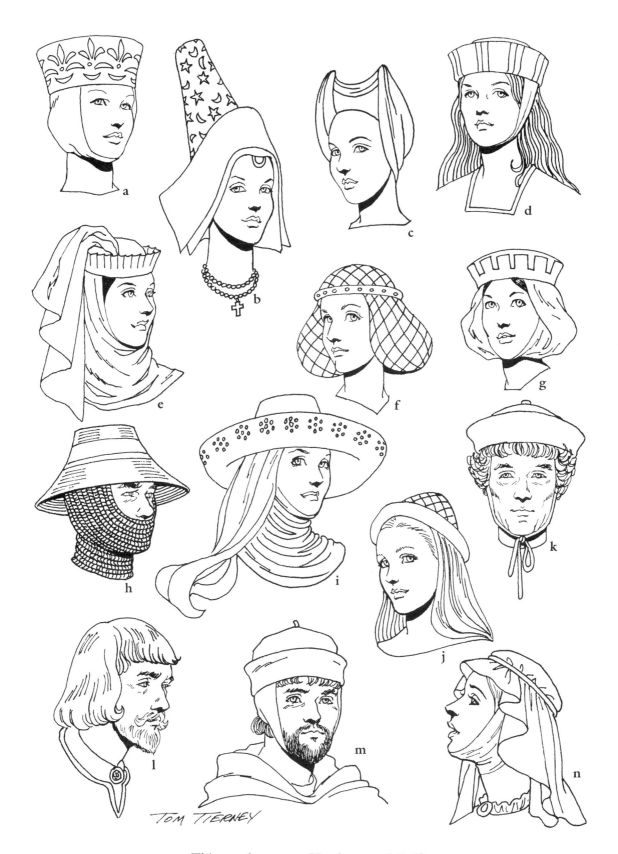

Thirteenth-century Headgear and Coifs

a. Embroidered linen toque with chin-band. **b.** Embroidered hennin with black velvet fold worn over a white cap and front loop. **c.** Two horned English hennin. **d.** Pleated linen toque with chin-band **e.** White linen headrail drawn through crownless toque. **f.** Jeweled circlet over crocheted wool net. **g.** Chin-band wimple and castellated linen toque. **h.** Straw hat worn over soldier's chain mail hood. **i.** Broad brimmed felt hat worn over a wimple and veil. **j.** Modified, stuffed and rolled hennin with padded circlet. **k.** Man's toque with tie-on chin-band. **l.** Rolled under hairdo and beard of the period. **m.** Felt hat worn over cap with chin-band. **n.** Wimple with chin-band and circlet.

25

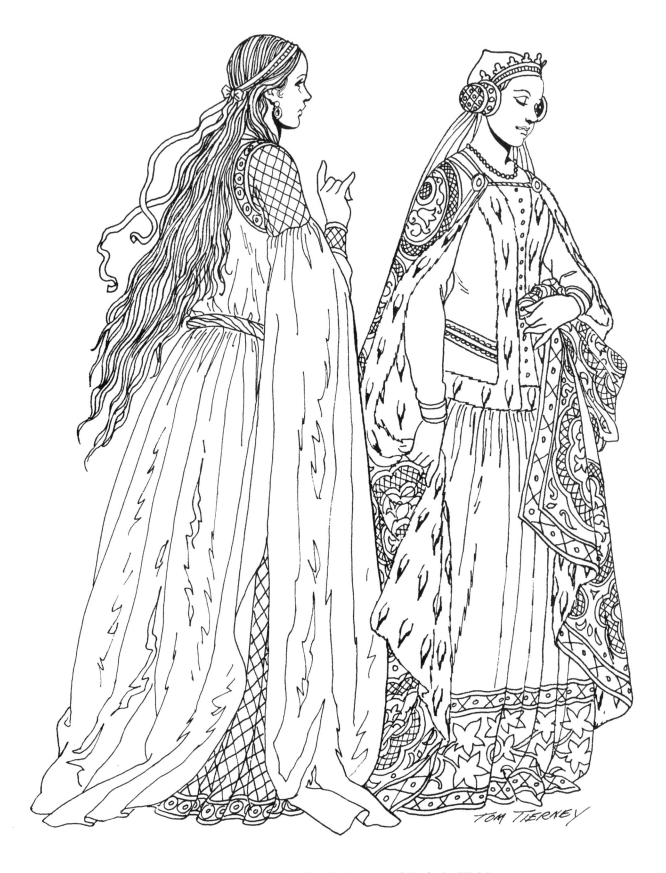

Fourteenth-century English Princess and Lady-in-Waiting

Left: The lady-in-waiting wears a belted bliaud over an embroidered chainse. The sleeves are the same fabric as the bliaud. **Right:** The princess wears a fitted cote trimmed in ermine over an embroidery-edged bliaud. Her mantle is brocaded, lined with ermine. On sides of her head she wears cylinder cauls topped by a crown over a peaked cap.

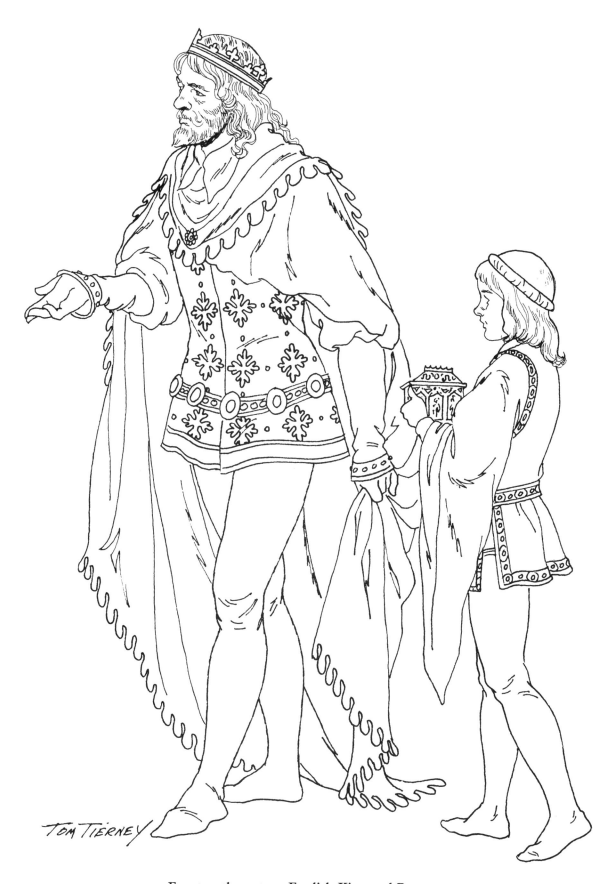

Fourteenth-century English King and Page

The King wears a brocaded tunic, a shirt with melon sleeves and knitted tights with feet. Petal scallops edge his mantle and he wears his jeweled girdle at his hip. The page wears a girdle at his waist; his sleeves are angel style.

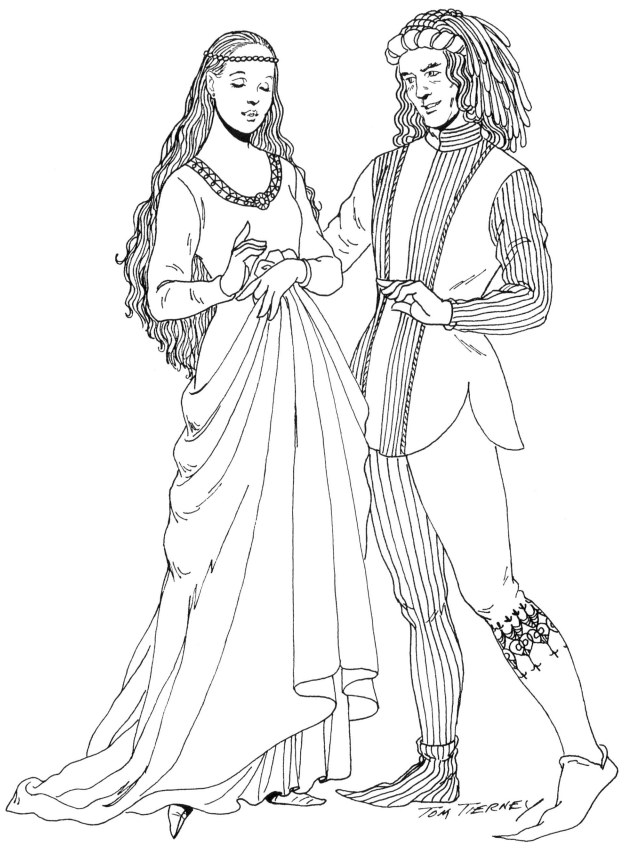

Fourteenth-century Dancing Court Couple

Left: She wears a fitted robe with a long train. **Right:** He wears a parti-colored jacket and tights. One leg of his tights has an embroidered garter; his shoes have long poulaine styled toes. His hat, a roundlet, has a chaperon cut into deep fingers.

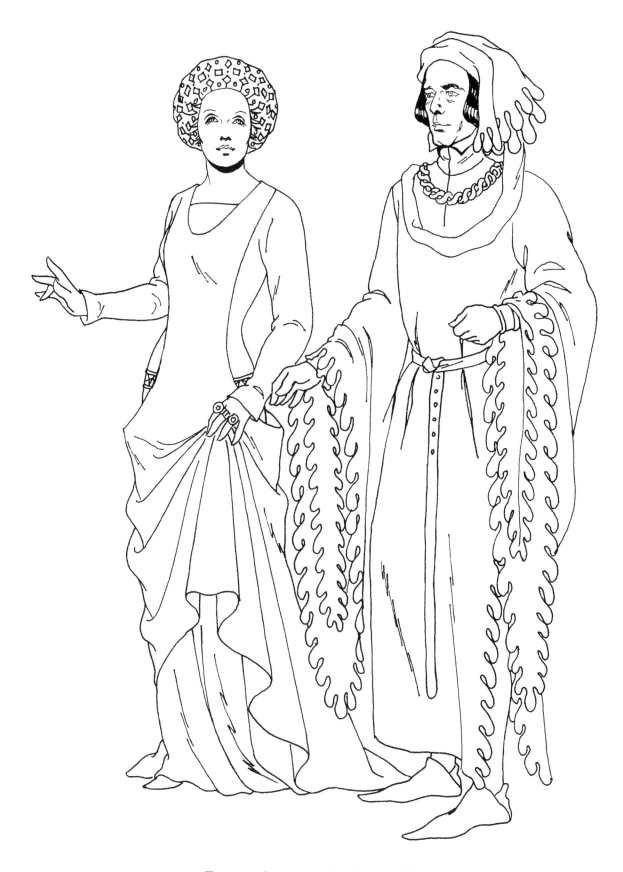

Fourteenth-century English Nobility

Left: The lady's surcoat is darker than the cote-hardie it covers. She wears a jeweled girdle at her hip and a jeweled caul on her head. **Right:** Over his lightweight, white tunic, the lord wears a brightly colored houppelande which is held at his waist with a long leather belt. On his head he wears a chaperon with a liripipe.

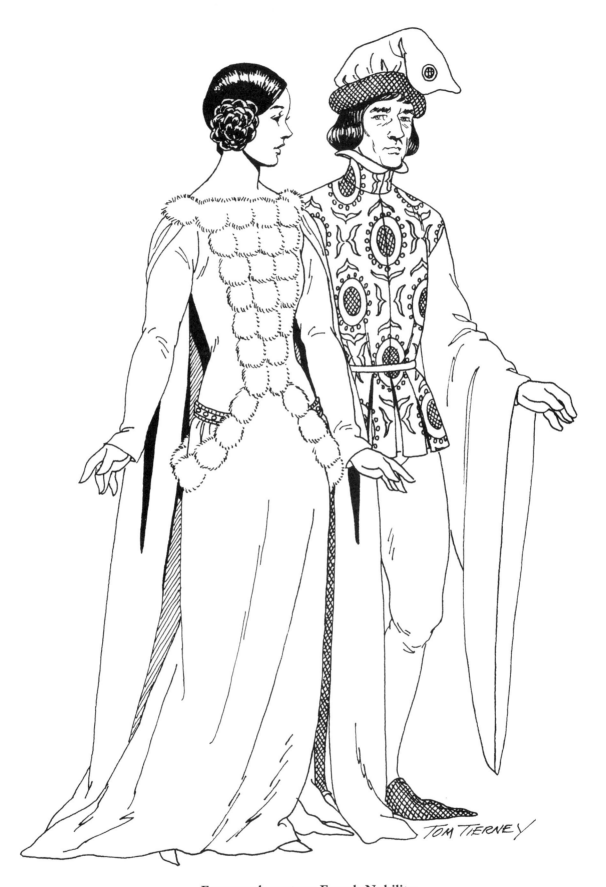

Fourteenth-century French Nobility

Left: This lady wears a pale colored cote-hardie, girdled at the hip. Her brightly colored surcoat has hanging sleeves and miniver trim. **Right:** The lord wears a bag cap with a padded, rolled brim and a jeweled ornament. His jacket is brocaded silk with velvet sleeves; his tights and shoes are parti-colored.

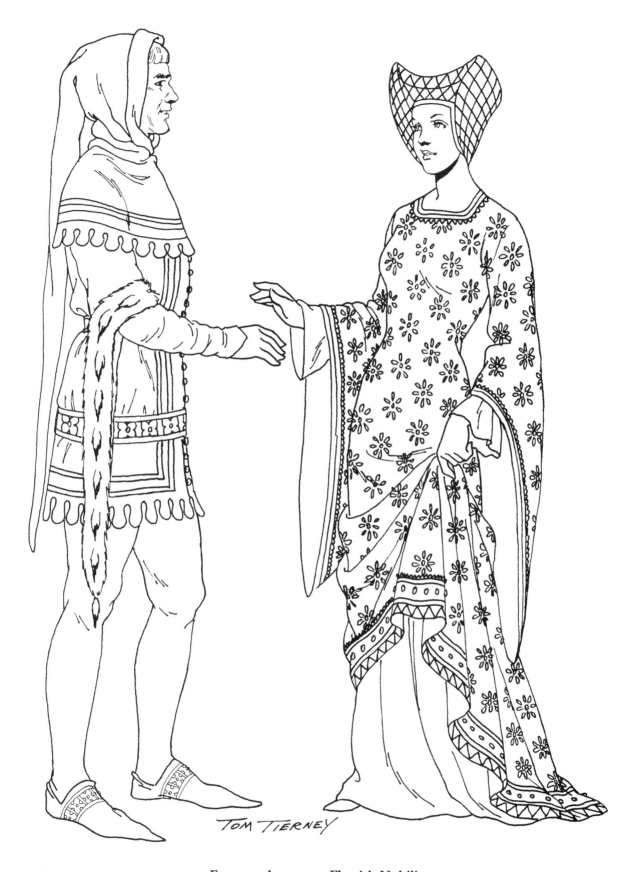

Fourteenth-century Flemish Nobility

Left: The gentleman wears a shoulder cape hood with a liripipe over a cote-hardie with a matching hem. The cote-hardie is accessorized with ermine cuffs and a jeweled belt. He wears dark stockings and embroidered shoes. **Right:** The gentlewoman wears a diaper patterned cote-hardie covering a white tunic. Her silk hennin has a braided net.

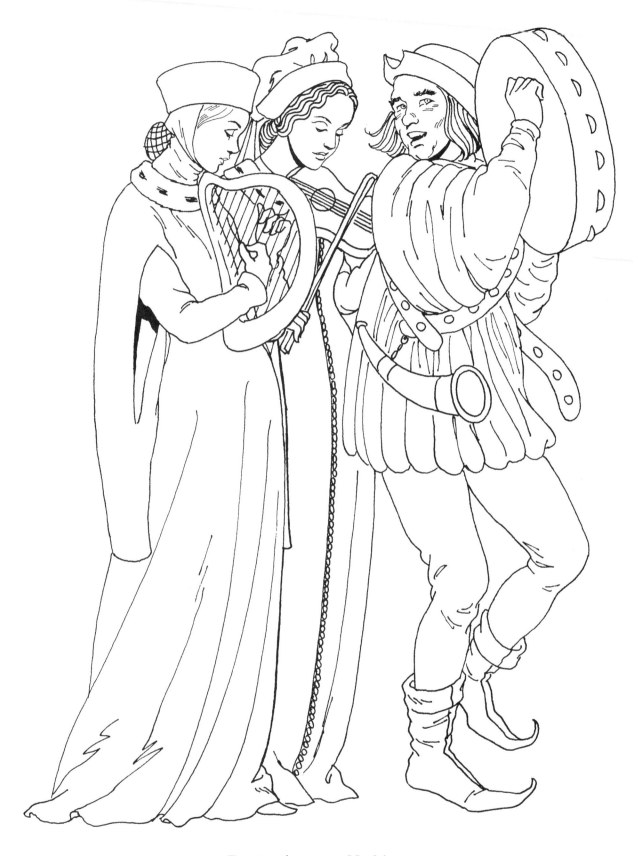

Fourteenth-century Musicians

Left: This woman wears a cote-hardie with hanging sleeves and an ermine collar. On her head is a wimple, chinstrap cap, and toque. Center: This musician wears a cote-hardie with a bag cap. **Right:** The man wears a deeply bloused tunic with bag sleeves over wool tights and high leather boots. A horn hangs from his silver belled baldric. Since commoners could not afford most brightly dyed fabrics, the colors here would probably be soft, natural tones.

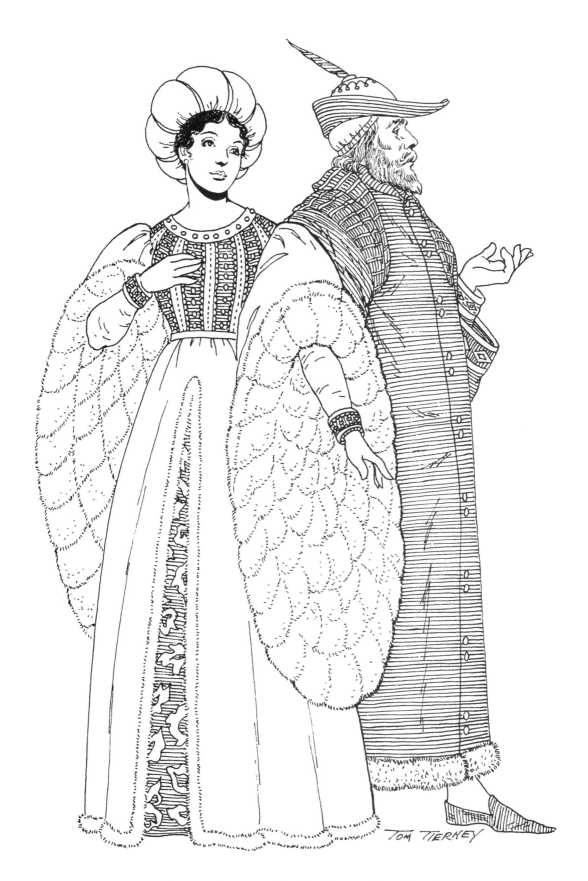

Fourteenth-century Italian Upper Class Couple

Left: She wears a gown with a jeweled bodice and a fur-edged, front slit skirt over a brocade underskirt. The enormous, dogaline sleeves are lined with soft fur. On her head is a stuffed, satin turban. **Right:** His houppelande has embroidered cuffs and a fur trimmed bottom edge. Topping his linen cap is a felt hat with a peaked brim and feather.

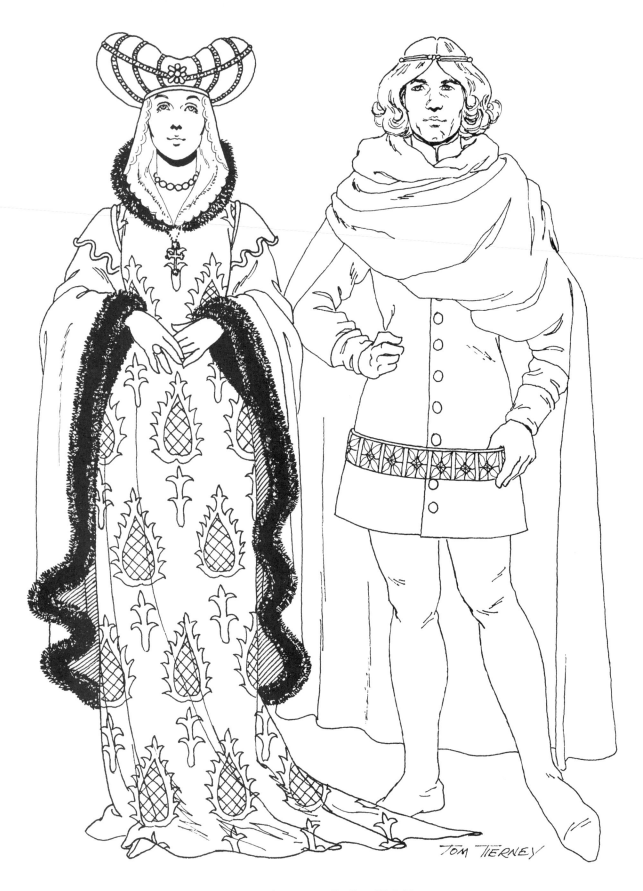

Fourteenth-century Italian Nobility

Left: The lady wears a brocaded robe featuring long flowing sleeves and a train. Her wimple and padded silk hennin are bound with gimp and trimmed with fur.

Right: The gentleman wears a short tunic with a gold, enameled and jeweled girdle. His mantle is doubled and puffed around his shoulders.

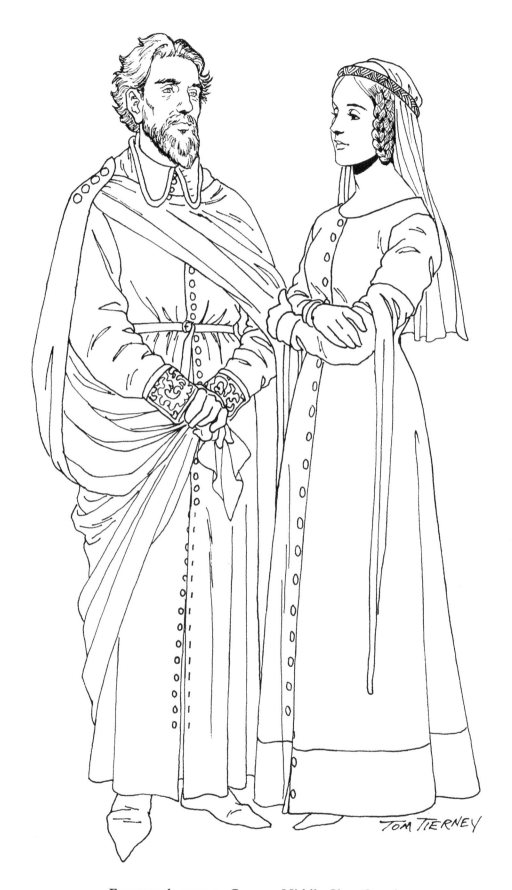

Fourteenth-century German Middle Class Couple

Left: The man's bliaud, which buttons down the front, is covered by a mantle which fastens at the shoulder.
Right: Featuring short sleeves with tippets hanging to the knee, the lady's bliaud buttons down the front as well. Underneath she wears a long sleeved chainse.

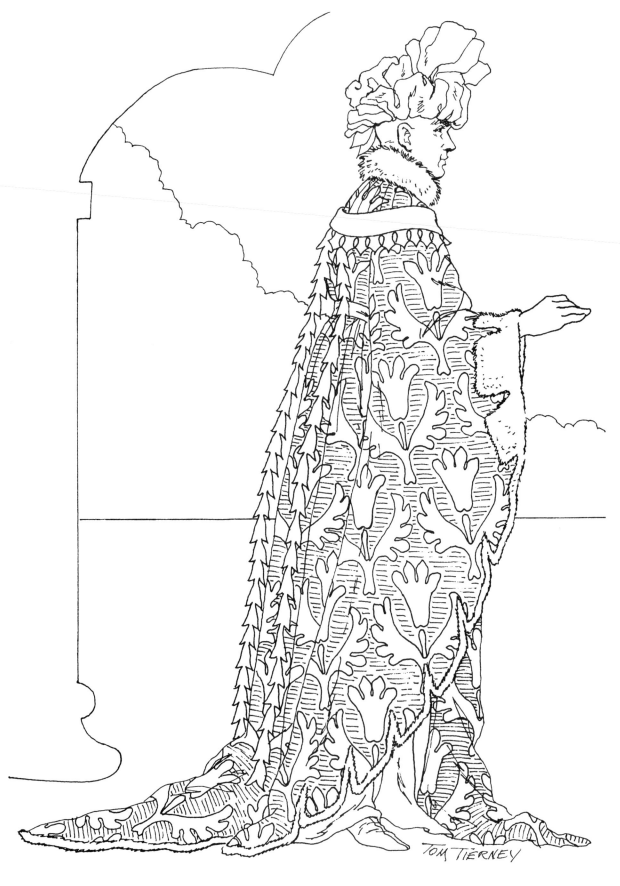

Fourteenth-century French Nobleman

This gentleman wears a fur lined houppelande of brocaded silk with castellated edges on the Dalmatian sleeves. The skirt is slit at the sides with dagged ribbons trailing down the back. His hat is chaperon style.

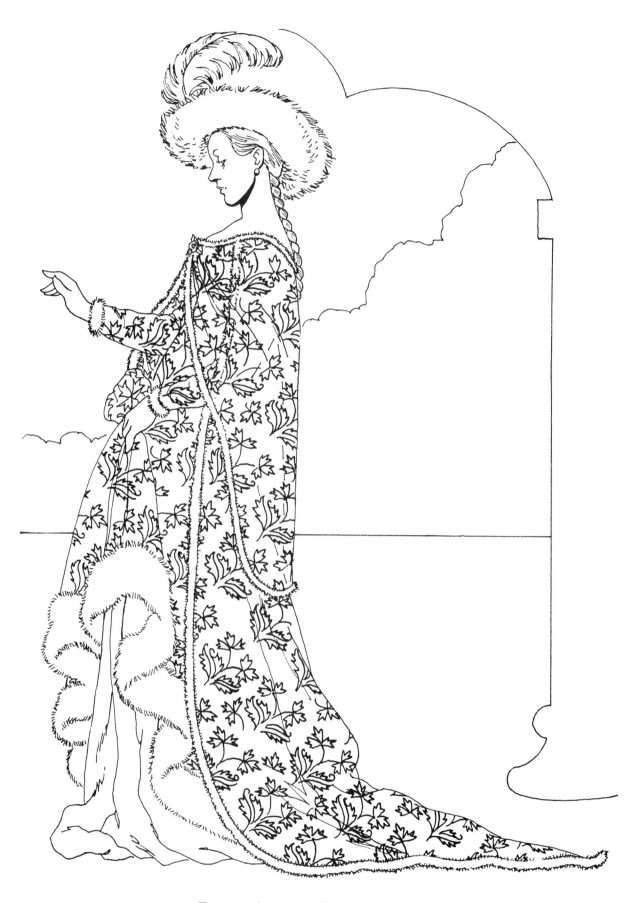

Fourteenth-century French Noblewoman

The silk brocade houppelande of this lady has a sheer over-cape. Her skirt and cuffs are edged with fur bands that match the plumed fur hat.

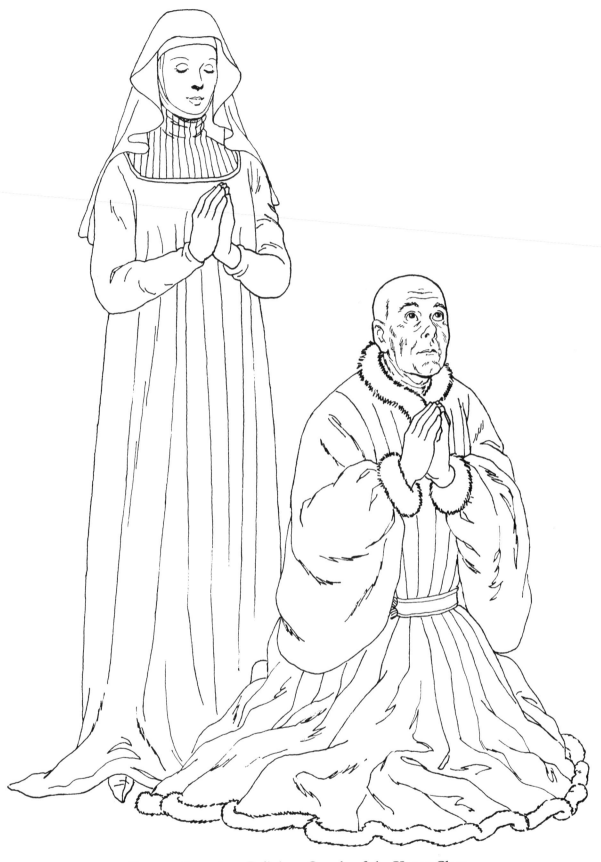

Fourteenth-century Religious Couple of the Upper Class

Left: The woman wears an unbelted bliaud with a pleated gorget and a plain headrail, traditional garments which date back to the twelfth century. **Right:** The man wears a knee-length tunic which is pleated and belted. With full bag sleeves, it has fur trim at the collar, sleeves and hem.

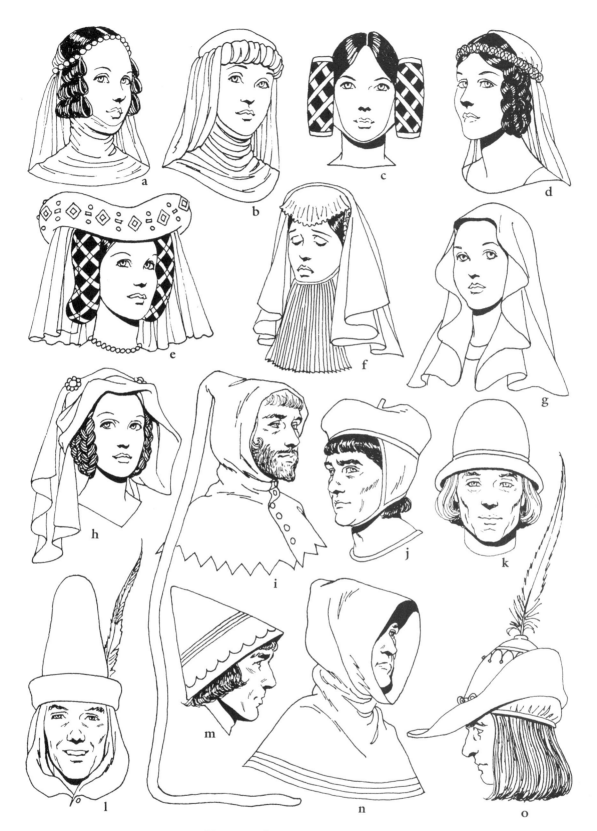

Fourteenth-century Headdresses

a. Gorget or wimple with a sheer veil worn as a headrail with a pearl circlet. Hair is looped over the ears. **b.** Gorget and gathered headrail which is tucked onto a headband. **c.** Cylindrical cauls worn with a chinband. **d.** Jeweled circlet with sheer headrail. **e.** Stuffed, rolled, and jeweled hennin worn with reticulated cauls and veil. **f.** Widow's mourning pleated barb, worn over the chin, with mourning veil. **g.** Simple headrail. **h.** Headrail pinned up in the style of a chaperon. **i.** Man's hood with liripipe and shoulder cape. **j.** Man's felt cap worn over a coif cap with chin strap. **k.** Man's felt hat, page boy haircut. **l.** Man's sugarloaf hat worn over a hood. **m.** Man's conical felt hat. **n.** Man's hood with caul. **o.** Man's felt hat with peaked brim. Worn over a cap, it is topped with a feather.

39

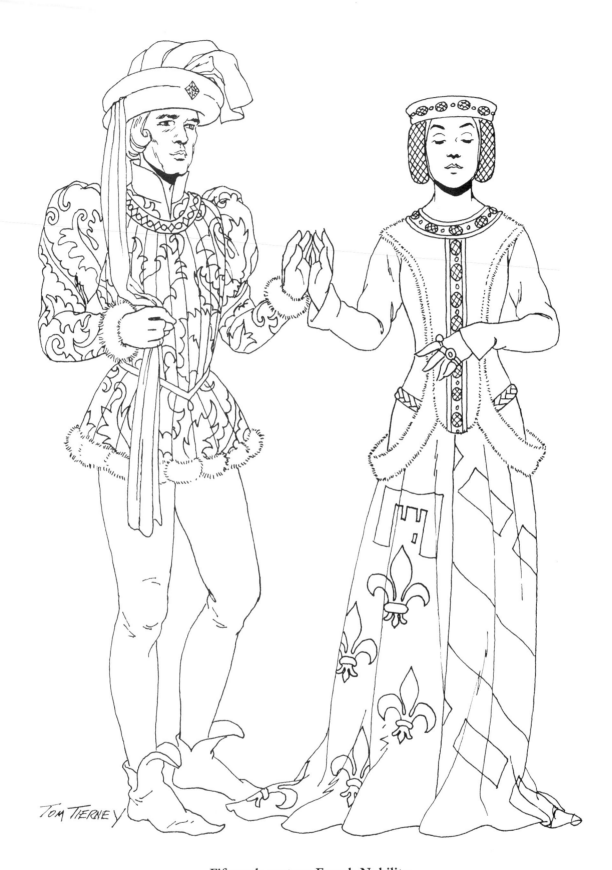

Tom Tierney

Fifteenth-century French Nobility

Left: The nobleman wears a short, pleated, brocaded tunic and a jeweled necklace. On his head is a padded roundlet with a chaperon. **Right:** The noblewoman wears a surcoat over a parti-colored skirt with an appliqué representing the family's coat of arms. The fur bodice of the surcoat has an embroidered and jeweled collar and closure. Under the surcoat is a long sleeved, hip girdled cote-hardie. On her head she wears a jeweled toque, chin strap, and reticulated net cauls.

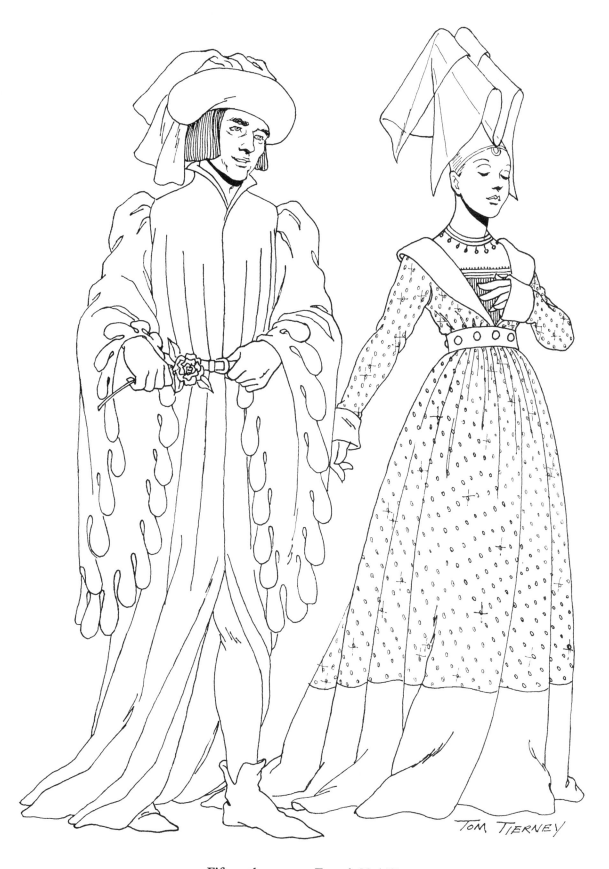

Fifteenth-century French Nobility

Left: This nobleman wears a houppelande with petal scalloping. His hat is a padded roundlet with chaperon.
Right: The lady wears a gown and hennin of metal shot silk, trimmed with a boldly colored velvet hat band, collar, cuffs, hem and jewel-studded belt. Her sheer veil is wired to hold its butterfly shape.

41

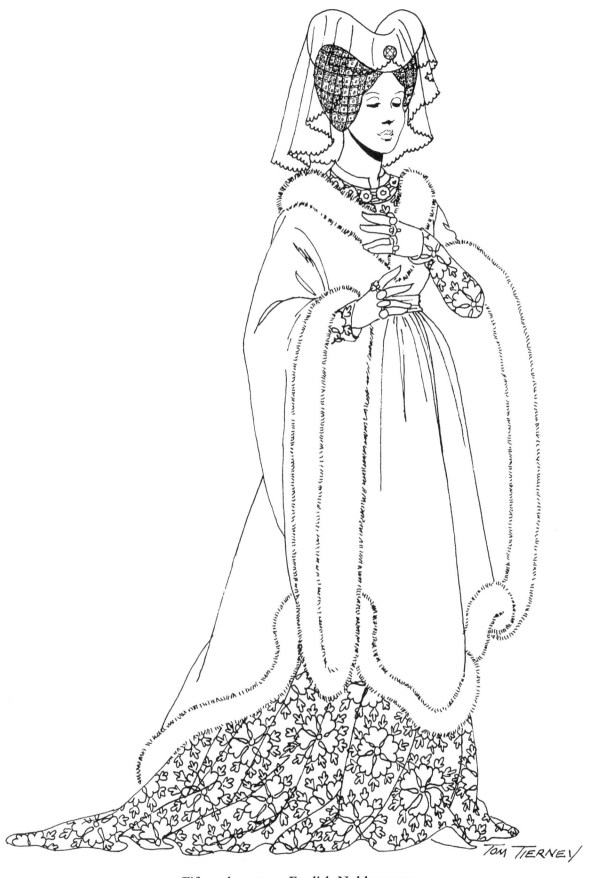

Fifteenth-century English Noblewoman

The lady wears a fur lined houppelande over a gown of gold brocaded silk. Around her neck she wears a jeweled necklace. Her rolled, heart-shaped, silk hennin is embellished with a jeweled net reticulated caul.

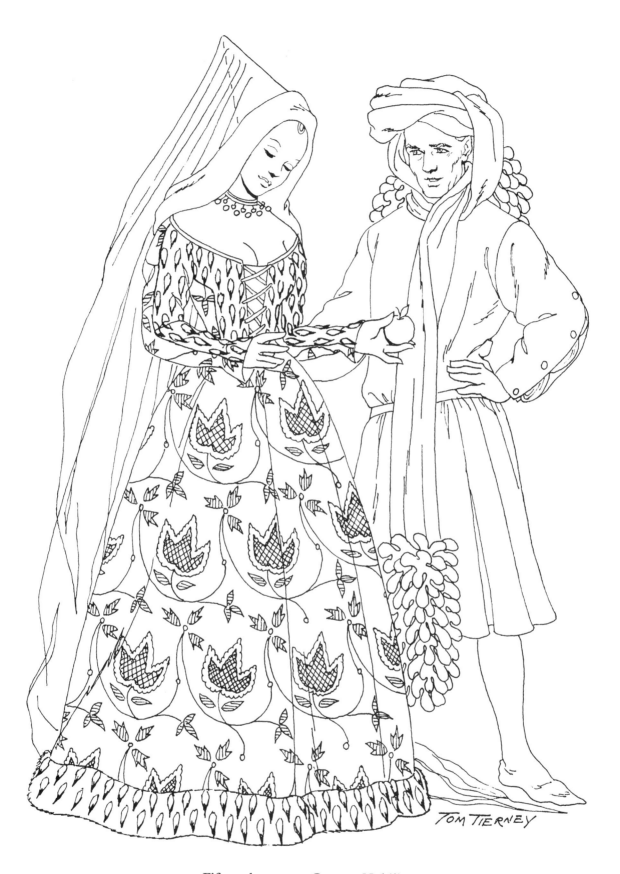

Fifteenth-century German Nobility

Left: The noblewoman wears a silk robe with an embroidered pattern. The fitted bodice and the skirt hem are trimmed in ermine. On her head she wears a steeple hennin with a black lappet band covering the lower edge. Showing at her forehead is a frontlet ring which is part of the wire cap under her hennin. **Right:**

The gentleman wears a knee length cote-hardie. The shirt fabric is pulled through the spaces between the buttons on the sleeves to create puffs. He wears a petal dagged chaperon with a petal edged liripipe hanging down the front.

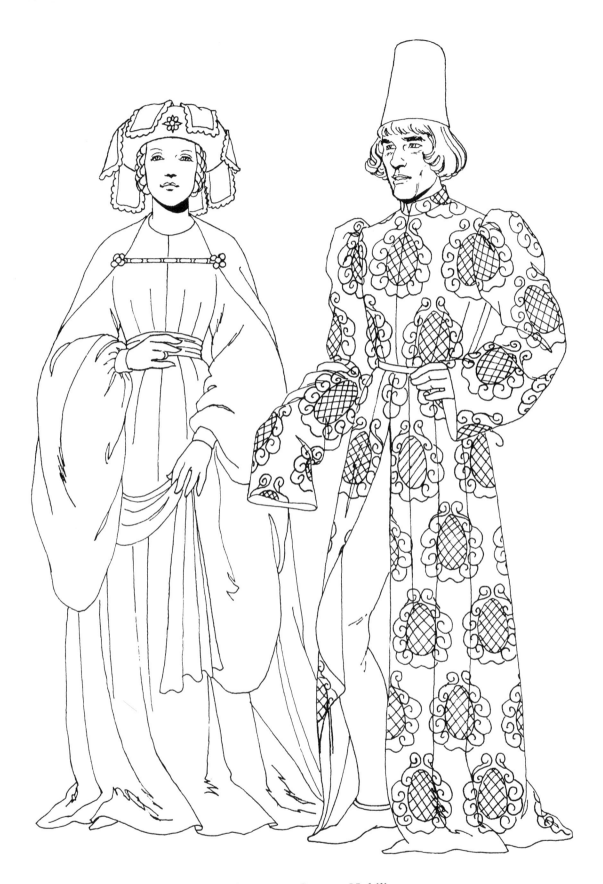

Fifteenth-century German Nobility

Left: This lady wears a gown with full bag sleeves under a mantle with a cord closure. On her head is a padded turban with a jewel pin. The veil tabs have castellated edges. **Right:** The gentleman wears a brocaded houppelande with padded shoulders and long, exaggerated sleeves. He wears dark shoes, tights, and a felt sugarloaf hat.

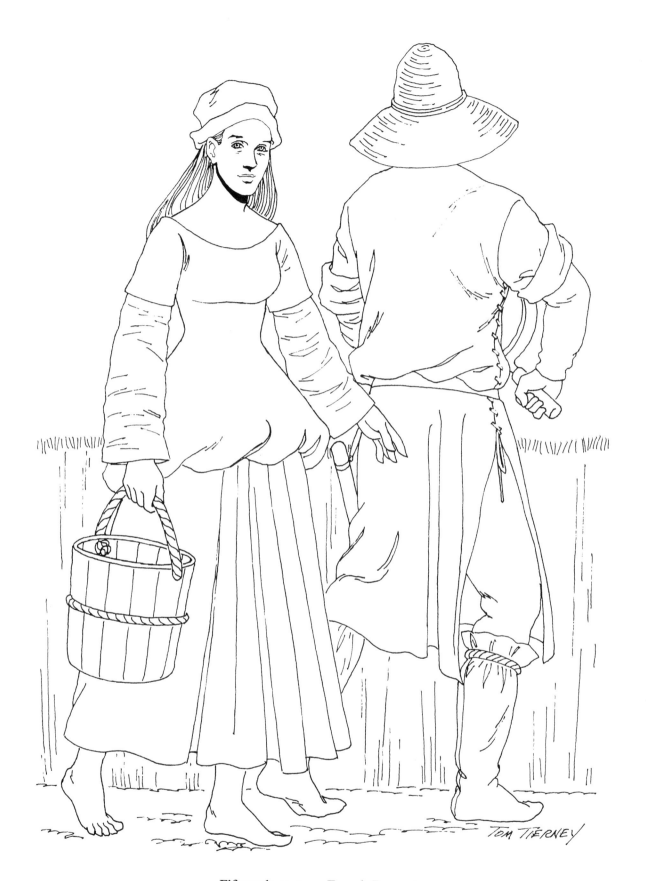

Fifteenth-century French Peasants

Left: The woman wears a robe with a fitted waist, the result of lacing in the back. Her skirt hem is tucked into the band around her hips to protect it from getting dirty, exposing her chainse. On her head she wears a cloth cap with a rolled head band. **Right:** Over his shirt (sherte) and braes, the man wears a laced cote which is open at the sides. His leather stockings are held up with leather rope. He wears a wide brimmed straw hat.

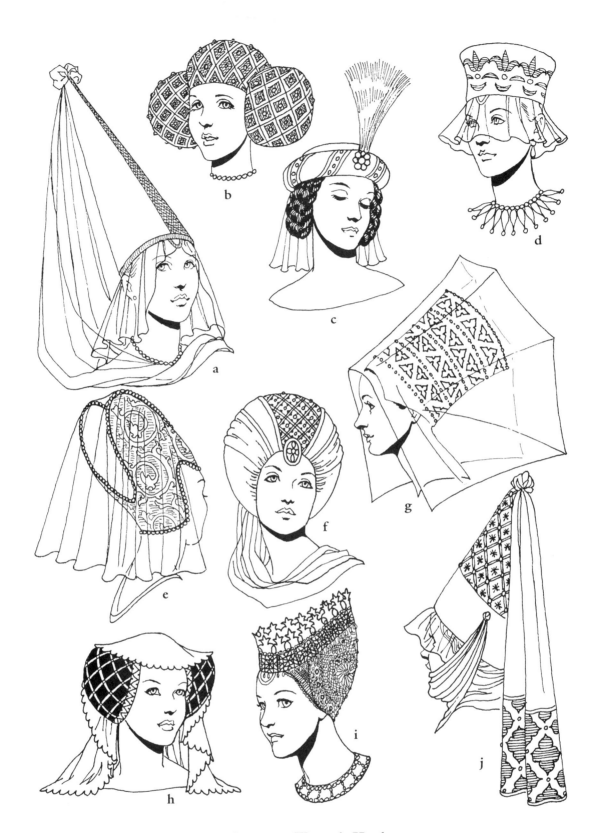

Fifteenth-century Women's Headgear

a. Steeple hennin, parti-colored, with frontlet, worn over a headrail of veiling. A soft veil hangs from the point of the hennin. **b.** Headdress of reticulated gold braid and pearls with drum cauls. **c.** Jeweled linen turban with veil and heron plumes. **d.** Felt embroidered toque with wired veil. **e.** Escoffion, or two horned hennin, made of brocaded silk, edged with pearls. Soft veil. **f.** Padded linen turban with jewels, pearls and gold braid. A liripipe hangs from the turban to the floor in back. **g.** Jeweled cap with wired veil. **h.** Wimple with castellated edge over reticulated cauls. **i.** Jeweled crown over reticulated caul. **j.** Diaper patterned steeple hennin with wired veil and gorget attached to band. Veil edged with brocaded band.

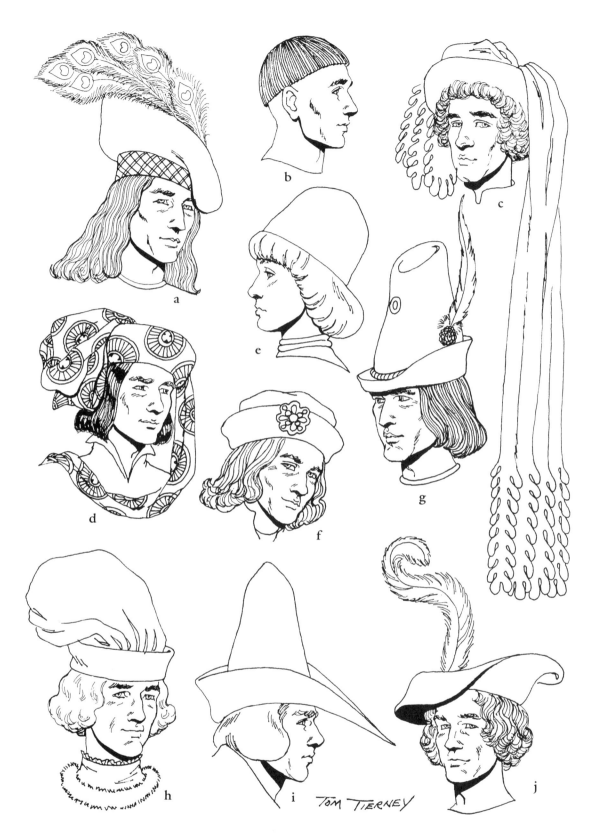

Fifteenth-century Men's Headgear

a. Felt hat with braided bandeau and peacock feathers. **b.** Cap cut hair style. **c.** Roundlet with dagged chaperon and liripipe. **d.** Chaperon turban with liripipe in brocaded fabric. **e.** Cloth hat with page boy haircut. **f.** Cloth hat with turned-up brim and jeweled pin. **g.** Felt sugarloaf hat with rolled brim, jeweled pin, feather, and cord hatband. **h.** Velvet bag hat with rolled brim. **i.** Wool peaked hat with set-on peaked brim. **j.** Felt hat with cap crown, rolled brim, and feather.

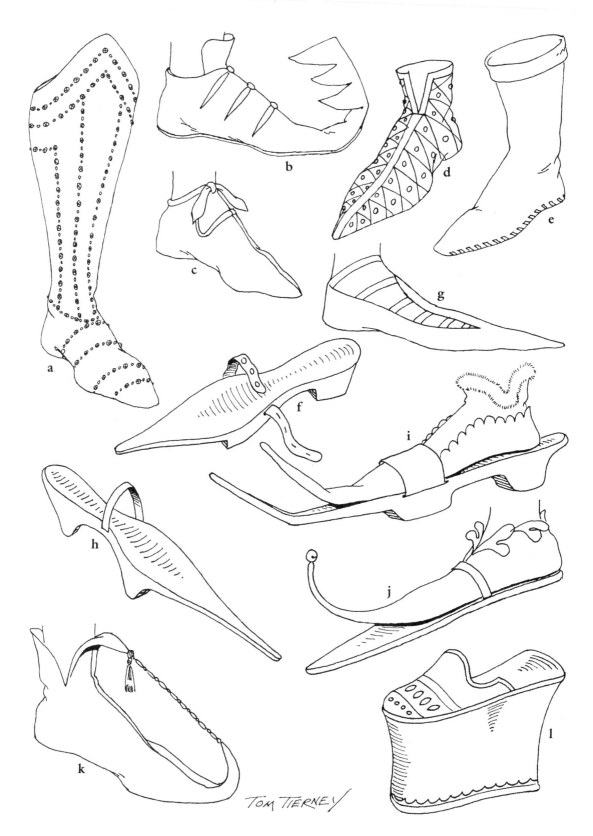

TOM TIERNEY

Medieval Shoe Styles

a. Soft leather boot with jewels (10th c). **b.** Low topped button-on shoe with padded "scorpion" toe (12th c). **c.** Soft, low leather tie-on shoe (13th c). **d.** Soft, low, leather shoe with embroidery and pearls (11th c). **e.** Soft leather boot with sewn-on sole (11th c). **f.** Wooden patten worn outside to protect poulaine styled shoes (14th c). **g.** Low topped shoe with straps and pointed, padded toe (14th c). **h.** Wooden patten with modified heel (15th c). **i.** Poulaine style shoe on a patten with padded toe, dagged trim and fur at the ankle (14th c). **j.** Shoe and wooden patten (15th c). **k.** Man's boot (15th c). **l.** Lady's chopine (15th c).